Expl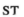en

ST

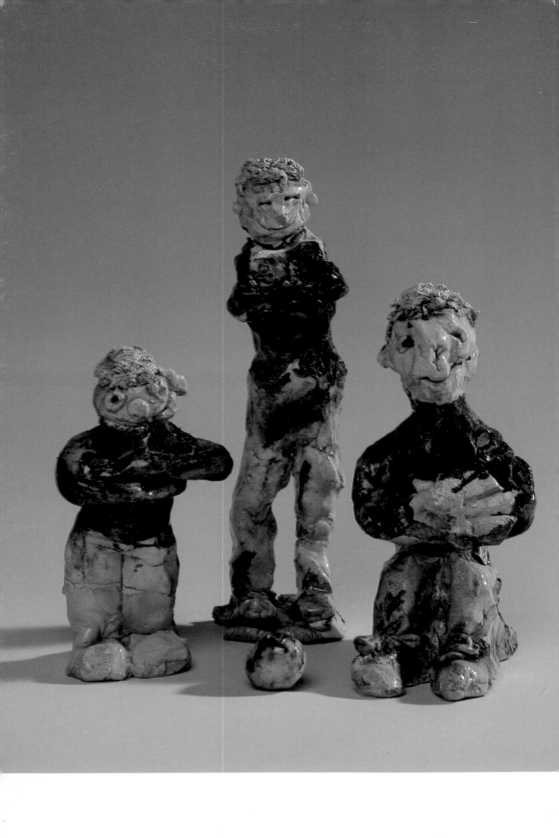

Exploring Clay with Children

Chris Utley and Mal Magson

A & C Black · London

First published in Great Britain 1997
A & C Black (Publishers) Limited
35 Bedford Row
London WC1R 4JH

ISBN 0-7136-4506-7

A CIP record for this book is available from the
British Library.

Cover illustrations

Front A giraffe by Katrina

Back A frog made by Class 7, Malton County
Primary School

Frontispiece Three footballers made by Class 7,
Malton County Primary School

Design by Alan Hamp

Printed in Spain by G.Z. Printek

Contents

Acknowledgments

We would like to give our warm thanks to all the people who helped us with the task of compiling this book, especially Jonathan Chapman, Rosemary Rayne, Derek Utley and all the children who worked on the projects.
The colour photography was done by Ken Shelton.

Preface

This book is aimed at primary school teachers who have little or no experience of working with clay. Through the book we hope to pass on our enthusiasm for clay by offering ideas, simple to follow instructions, and suggestions for the development of clay activities in the classroom.

It is a classroom-based reference book which could be used for staff training and curriculum planning, as well as for practical sessions with children. It will encourage the natural development and diversity which children bring to the tasks set them. It is suitable for schools with or without a kiln or specialist facilities.

There are sections on general topics such as the care of clay and where to find it, and sections containing a large number of practical activities. Some of these activities are used to illustrate basic techniques, others give free rein to the children's imagination. A glossary at the end of the book explains some key terms used.

Macon aged 7 applying brush-on glaze to his soft slab room

Chapter One
Getting to know about clay

Introducing clay to the children

Clay is an amazing material and plays an enormous part in our lives. It is strong enough to build houses, yet delicate when used to make porcelain tea cups.

A good start to introducing clay would be to get the children to think of all the things in their homes that are made of clay, from house bricks, tiles, drains, toilets, washbasins, to the more obvious cups and plates.

You could set up a display area with a variety of clay objects collected by the children.

Find out if there are any tile, pipe or brick works nearby and perhaps a visit could be arranged. Sometimes it is possible to get clay from brickworks.

Digging your own clay is a great way of seeing exactly where it comes from. You will find a project on doing this later on in the book (page 61).

Types of clay

The most common types of clay offered in school catalogues are red and buff earthenware. Either is fine, but we suggest that if you are going to use slips and coloured glazes (see below) on the work, buff clay will give a better colour response. If the work is to be left in its natural state, or have a simple transparent glaze, the red clay looks warm and rich.

Health and safety

Whilst we do not wish to frighten you away from using clay, there are some important rules that need to be stressed, particularly as regards dust.

Dry clay is dusty and bad for you if you inhale it. Do not sweep the floors and worktops. Use wet cloths, sponges or mops to clean all surfaces.
Wash tools after use.
Children should wear aprons. If they are plastic, give them a wipe after the session.

Material – aprons, old shirts etc. – should be washed regularly.

Clay itself doesn't harm if ingested, but glazes and colorants are hazardous and should not be put in the mouth. Check on manufacturers' labels.

Wash hands after the session.

The care of clay

There is nothing sadder or more off-putting than a plastic bag or bin full of dried up old bits of clay. A few simple steps will help you keep your clay in good condition.

- When you get bags of new clay, check them for splits in the polythene (wrap in plastic bags if they are split), then store them in a cool place away from heat.
- Do not let the bags get frozen, as this does not help the clay.
- Once the bag has been opened, it is important to keep the contents plastic (i.e. soft). Do this by always keeping the clay covered when not in use.
- Put in a plastic bin with a tight fitting lid.
- Store well away from heat and check to make sure it isn't drying out. A quick spray with a small amount of water could help, and perhaps some polythene over the top of the clay, especially if your bin lid doesn't fit tightly. Polythene from the dry cleaners is excellent.

- It is a good idea to get into the habit of checking the state of the clay on a regular basis.
- Whilst the children are working with the clay, get them to put all leftover pieces into a polythene bag. Dampen this with a little water.
- When the session has finished, these bits can be easily bashed into a ball and made workable again. This way, you will not be left with lots of little dried up bits to deal with or, even worse, to throw away! Just squeeze and knead the pieces together as if you were making bread. The only difference is that when you make bread, you put air in, and we want to take it out! Knead it until you have a smooth consistency, then bang it into blocks and put into a bin.

If your clay has dried out, it is possible to reconstitute it.

- Put it into a bucket and cover with water. When the clay has disintegrated into a thick mush, slop this out on to wooden boards, and leave it to start drying. This will take several days depending on the heat in the room. When it is dry

enough to knead without sticking to the table, it is ready. Knead into balls and store in a plastic bin.

Tools and materials

Some suggestions to help you get together a good selection of equipment for a clay area:

Things you can buy

- *Bins* One or two plastic bins, with tightly fitting lids, to store the clay
- *Rolling pins*
- *Laths* to use as thickness guides when rolling clay
- *Small boards* for working on
- *Loop-ended modelling tools*
- *Packs of pottery tools* These can be bought from most school suppliers
- *Material for rolling out clay on* The weave of the cloth will texture the clay. Some suitable materials are: hessian, floor cloth, calico, thick cotton, scrim

Things you can collect

There are lots of everyday things you can collect to make interesting additions to the selection of bought tools. These are particularly useful as 'texture tools' for making marks on the clay. Here are a few simple suggestions to start you off:

- *rubber car mats*
- *old hacksaw blades* for cutting and scraping
- *old plastic cashcards* cut into shapes for scraping
- *vacuum hose* to roll on the clay surface
- *garlic press* for extruding bits for hair or fur
- *old kitchen utensils: knives, forks, spoons*
- *corks* – patterns can be cut into the surface of the cork
- *pieces of dowel* of different thicknesses
- *screws* – use the head to make patterns
- *patterned lids*
- *bits of lego or unifix*
- *margarine and ice-cream tubs*

Chapter Two
Getting to grips with clay

In this chapter we present five projects, each one showing a different technique for **shaping** the clay. Each project will also show the main stages involved in making pottery:

Preparing
Shaping, and joining pieces by means of slip*
Decorating using material, tools or coloured slips*
Drying
Firing** and glazing*

The basic techniques, with their projects, are:

Technique
1 *Pinching*
2 *Coiling*
3 *Modelling*
4 *Slab making*
5 *Using simple plaster casts*

Project
Making a pinch pot
Making a coil pot
Making an animal
Making a three-dimensional building
Making a relief tile

*For further notes, see Glossary p.70
** See Chapter Five

Project: Making a pinch pot

You will need
clay, small board, paper towel or newspaper, tools to decorate

 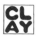

Method

1. Prepare your clay

If you have a new bag of clay, use the cutting wire to slice off blocks small enough to fit into a child's hand. Pat this into a ball.
If the clay is from the bin, collect a small ball and pat it smooth.

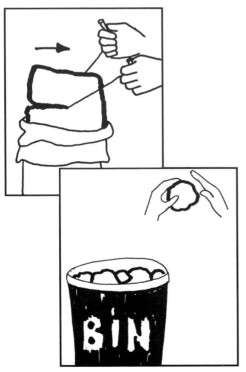

2. Now to start the pot

Hold the ball of clay in the palm of your left hand if you are right-handed. Push the thumb of your right hand gently into the clay. Aim to nearly reach the bottom but don't go through the base!

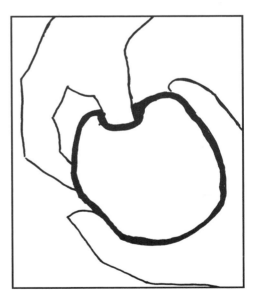

Reverse this for left-handed people. Slowly revolve the ball of clay in your hand, by pinching the clay between thumb and fingers. Work from the bottom of the pot.

13

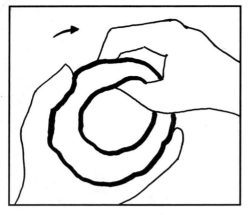

Think about the shape.
Do you want an open or closed shape? If you pinch with your thumb on the inside, you will notice the pot opens up.
If you pinch with your thumb on the outside, you can turn the pot inwards.

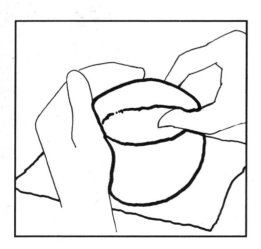

Pinch the pot, gently thinning the walls and trying to control the shape. Try and keep the rim fat until the end. This will help keep the shape and stop it cracking. Smooth the outside.

Decorating

If there is time, leave the pot to firm up a bit before starting – about 15 minutes if the room is warm.
- Impress patterns with tools.
- Scratch patterns.
- Paint with slip and scratch through the slip.

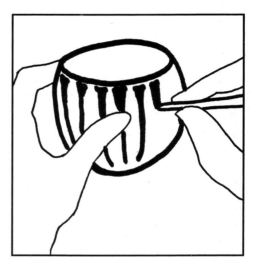

Finishing off

Leave the pot to dry thoroughly. If you have access to a kiln, you can paint the pot with coloured slips and fire it. It can then be glazed and fired again.
If you don't have access to a kiln, paint the pot after it has stiffened. Try a mix of 50% ready-mix paint with 50% PVA gluemix.

Pinch pots by Gemma and Hannah aged 8, painted with brush-on glazes

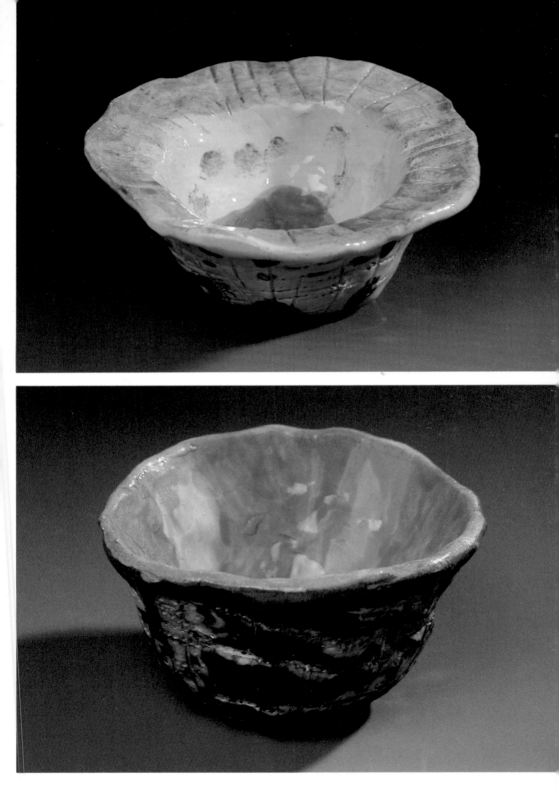

Above Coiling a pot
Right Frederick aged 9 coiling a pot
Below Making a coil

Project: Making a coil pot

Coiling clay to form pots is one of the oldest methods. It is still being used by potters the world over to produce both functional and decorative ware. It can be used to make lots of things once the skill of rolling the coil has been mastered.

You will need
clay, small board, paper towel or newspaper, pot of slip, comb or hacksaw blade, tools to decorate

Method

1. Prepare your clay

If you have a new bag of clay, use the cutting wire to slice off an oblong lump.
If the clay is from the bin, collect a ball.

Make the base of your pot. Pull a small piece of clay from your lump and pat it flat.
Put it on your board.

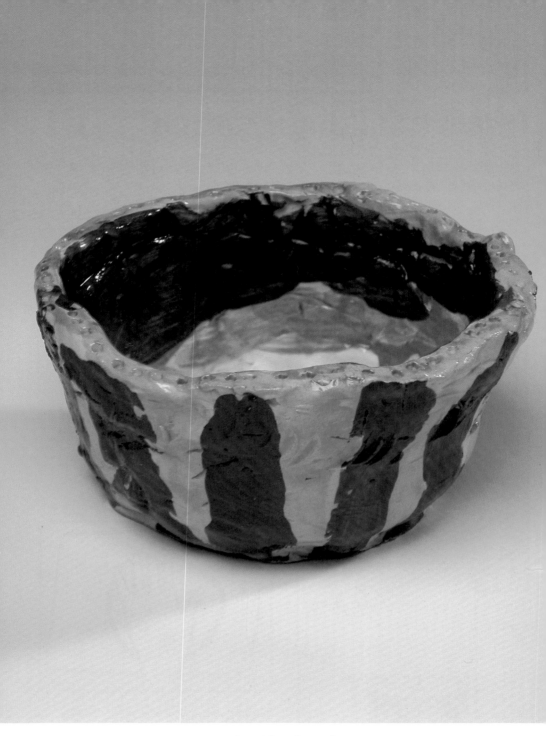

A coiled pot by Mark aged 7, painted with brush-on glazes

Now we are going to build up the sides of the pot by adding coils of clay.

Take another small lump of clay and lightly squeeze it into a fat sausage shape. Put this on your work board.

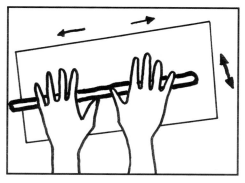

Very gently start to roll it out with the fingers.

Your hands should move from the centre outwards as you roll the clay.

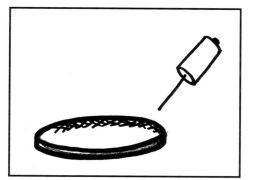

Next scratch the base of your pot and lay the coil on top.

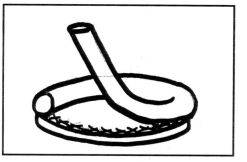

You will need to make sure that the clay is firmly joined together. You can do this by making sure that the inside surface of the coil is pulled firmly down to merge with the rest of the clay.

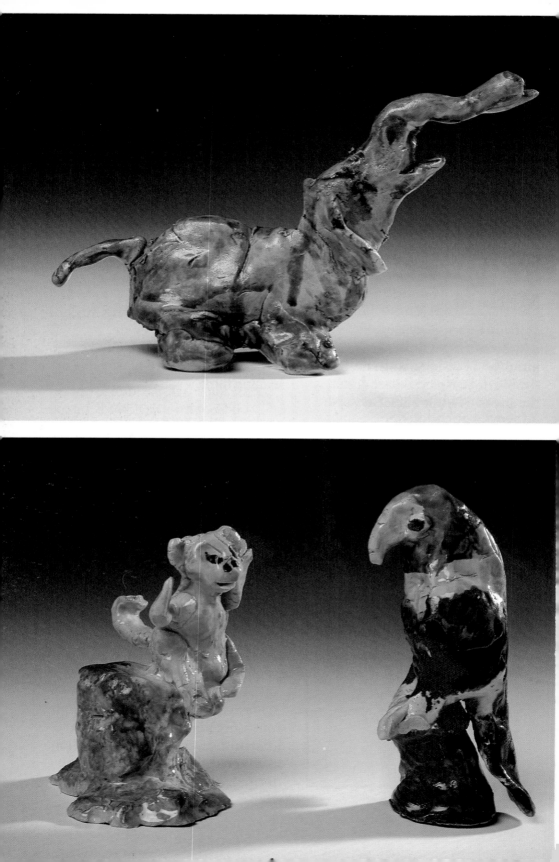

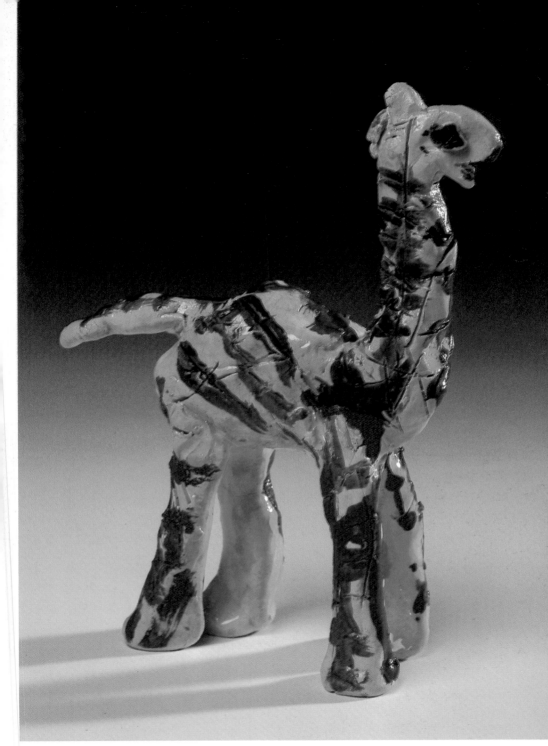

An elephant made by James aged 8

A parrot and a monkey made by Luke
aged 8

Above A giraffe by Katrina aged 8,
painted with coloured slips under a
clear glaze

legs, tail, neck and head out from the main lump. You may either hold the clay in the air or rest it on the table.

Children modelling various animals

4. You may prefer to model the limbs separately. Join them on to the body as you go by roughening both surfaces and gently pressing them together. If the clay is really soft, it will join easily, but you may find a light brush with water or slip will help the surfaces to adhere.

5. Stand the model in front of you to see how it looks. Support it wherever necessary by squeezing lumps of spare clay into props under various parts e.g. the main body, the tail, the head.

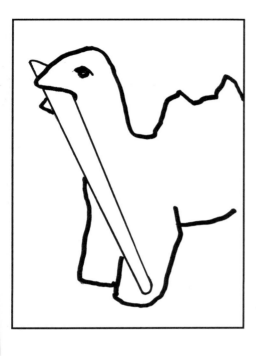

6. Use your fingers or modelling tools to refine the shape. Consider cutting a deep slash into the head for jaws, rolling small pellets for eyes, ears, teeth, tongue, claws etc. Flat shapes can be cut from thinly rolled slabs to make feet, scales etc.

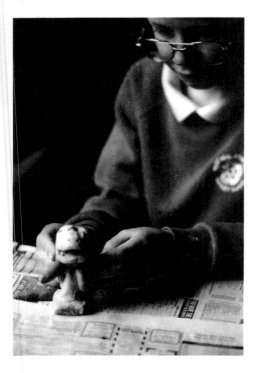

Above Fox by Eleanor aged 9
Left Frederick aged 9 finishing his monster

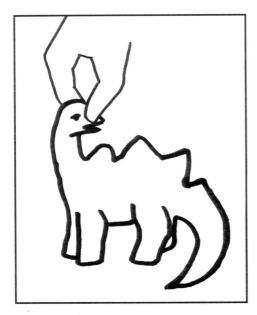

7. Keep viewing the model from different angles to see that it balances well.

You may need to adjust the length of the legs, tail or head to help it stand up.

Consider tilting the head and neck and altering the legs to suggest movement.

Make impressions on the surface to suggest skin texture.

8. Leave your model to stand for 20 minutes or so – the time will depend on the warmth of the room and the dampness of the clay.

Then gently remove the props and make good (e.g. smooth) the surface.

If the legs/neck/head start to sag, leave the props in place longer, but remember to remove them before the clay dries and hardens.

If the work is intended for firing, it is advisable to make a hole into the widest part of the body from the underside. You can use a modelling tool, a pencil or a piece of dowel to do this.

Finishing off

Leave the animal to dry thoroughly. If you have access to a kiln, you can paint the model with coloured slips and fire it. It can then be glazed and fired again.

If you don't have access to a kiln, paint the animal after it has stiffened. Try a mix of 50% ready-mix paint with 50% PVA gluemix.

Project: Making a three-dimensional room

You will need
clay; rolling pin; a flexible mat, board or paper towel to work on; cutting wire, modelling tools, pointed knife, old comb or hacksaw blade, fabric

Three-dimensional rooms made by Class 7, Malton County Primary School

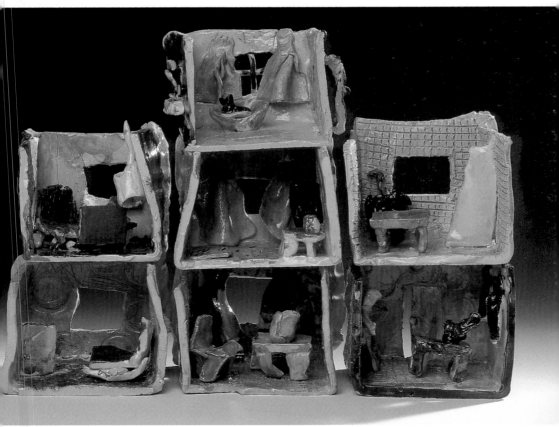

Method

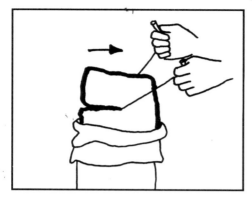

1. Cut a piece of clay from your bag of clay. If you cut it carefully, it will be in a thick tile shape and will require little rolling.

2. Place the clay on a piece of fabric or a paper towel. (This is to stop the clay sticking to the table. It can also give an attractive pattern to the surface, should you want it.) Roll out the clay with a rolling pin, just like a piece of pastry. To help give the clay an even thickness, use rolling guides (laths) placed at the sides of the work. Roll out the clay until the rolling pin runs along the top of the guides.

3. Whilst the clay is lying flat, cut out the shape of the room. Either cut the clay slabs into the requisite number of sides for your room or an easier thing to do would be to design a net shape. To do this, make a template of the shape, and lay it on the clay. Then cut round the template.

4. Whilst the slab is still flat, cut out or draw in windows and doors. Add details such as wallpaper patterns. This can be done with an old fork or maybe a small shell pressed into the clay to make a repeat pattern.

5. To assemble the room, rough up the corner edges of the walls and base, using a comb or hacksaw blade. Place the roughened edges together and pinch hard along the seam to join. If the clay is very soft and starts to sag, leave it to stiffen up a little. If it gets too hard, it makes the pinching together rather difficult, so a happy medium is needed.

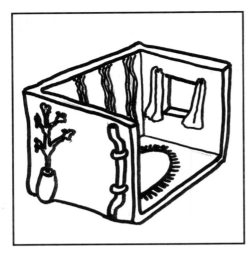

the two surfaces you wish to join, and paint them with a small amount of slip. Then push the two surfaces firmly but gently together. The rooms could be stacked together to form a house, or even a block of flats.

Finishing off

Leave the room to dry thoroughly. If you have access to a kiln, you can leave the room as it is, or paint it with coloured slips and fire it. It can then be painted with coloured or transparent glazes and fired again.

If you don't have access to a kiln, paint it after it has stiffened. Try a mix of 50% ready-mix paint with 50% PVA gluemix.

Add pellets and coils of clay to create different effects. Tear pieces of clay from thin slabs to make curtains. If the clay is really soft, it will join easily. If not, you may find that it is necessary to join by the scratch and slip method: roughen

Unfired clay room

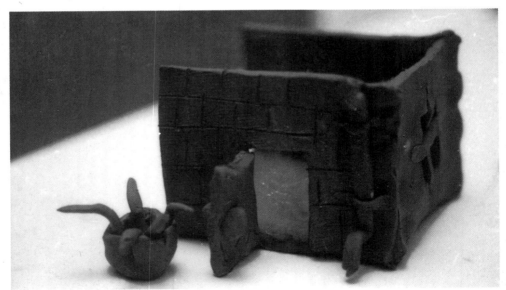

Project: Making a relief tile

You will need
a newly finished, unfired tile; clay, plaster, a flexible container (e.g. bucket
or tub), a stick or spoon to stir, newspaper or a small board

A plaster cast done by Lewys

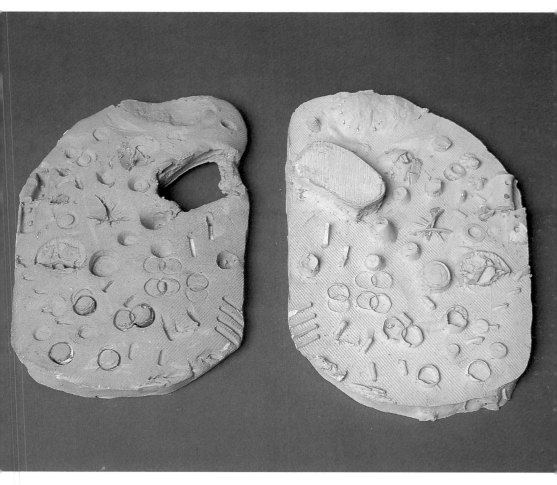

Method

1. Put the tile on a board or piece of newspaper.

2. Roll out a fat coil of clay (see coiling project) and flatten it with your hand to form a band.

3. Place this coil around your tile to form a wall. Make sure that the wall is completely sealed, by using your thumb to press the edges of the wall firmly to the board. This will be your mould.

4. Next, make the plaster. Put some *cold* water in a flexible container. Sprinkle the plaster onto the surface of the water. Slowly keep adding plaster until a

small peak of the plaster forms above the surface. Now it will be safe to stir the mixture without fear of lumps forming. Stir until the plaster is the consistency of thick cream. Carefully pour the plaster into the prepared mould. Watch out for leaks. These can be easily plugged with spare clay.

It is best to leave the residue of the plaster in the container to get hard. Then you can just flex the container and knock the plaster into newspaper for disposal. Do not put plaster down sinks or drains. It will block them!

5. When the plaster has dried, peel away the clay walls, and separate the clay tile from the plaster cast.

The clay from the walls cannot be used again, as plaster in clay will explode in the kiln.

6. Leave the plaster cast in a warm place to dry thoroughly. This is your press mould.

7. To use the mould, roll a slab of fresh clay no less than 1cm ($\frac{3}{8}$in) thick.

8. Place the plaster cast onto the surface of the slab and press firmly.

9. Cut and trim the impressed tile from the slab. Use a card template for accuracy.

10. Repeat actions 7, 8 and 9 to produce multiples of the original.

Finishing off

Lay out the tiles on an even surface, turning occasionally as they dry.

If you have access to a kiln, you can biscuit fire the tiles once they have dried (see Firing on p.66).

After biscuit firing, they could be glazed and refired.

If you don't have access to a kiln, you could paint the tiles after they have dried with a mixture of 50% ready-mix paint with 50% PVA gluemix.

Chapter Three
Further development
Ideas for taking the basic techniques further

In this section, we are going to develop the skills we introduced in the previous projects. Each project uses one or more of the basic techniques and will, we hope, be a starting point for many a brilliant idea.

Projects
a. Transport
b. Food
c. Pattern
d. Games
e. Beasts and mini-beasts
f. Forms from nature
g. The playground
h. Giant mouth, hand or foot
i. Buildings
j. Plaster stamps
k. Team photograph
l. Tiles
m. Pipe cleaner figures
n. Pots ancient and modern

Right A car and plane in unfired clay by Frederick aged 8, part of a project on transport

a. Transport

- Cars, buses, aeroplanes, and boats can be made out of solid lumps of clay. Remember to fix pieces together by scratching the edges to be joined, paint with slip and then press them together.

- Tiles with vehicles carved into the surface.

- Relief tiles. The subject should be cut from a rolled-out piece of clay, and added to the tile. The surface can then be drawn into by carving, impressing and scratching. A large class project could be done in this way.

- Press wheels, cogs, nuts, bits of perforated metal, chopped up rubber car mats, in fact anything you can find, into rolled out pieces of clay. This could be used as part of a larger frieze or be made into individual tiles.

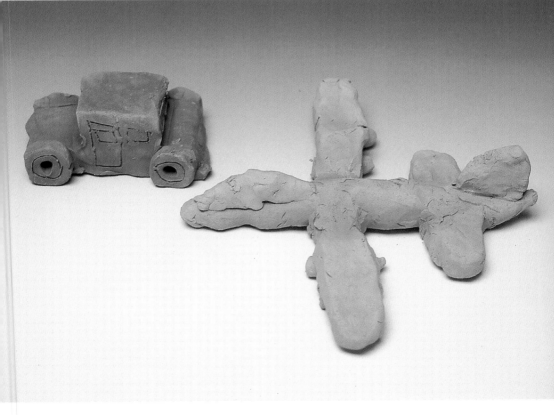

b. Food

- Make a plate of food.

 Pat out a soft slab of clay. Either cut it into a plate shape, or lay it onto a paper plate and trim it like a piece of pastry. Next make your food: roll, cut, pinch and coil clay into shapes. Peas can be pellets of rolled clay, chips cut from a slab, beefburgers patted slabs which can be textured by impressions; pizzas in the same way. Fix them on the plate by using small amounts of slip.

- Knives, forks and spoons can be made by pinching, rolling or cutting from slabs. Remember not to move delicate forms too much, especially when wet.

- A picnic cloth with all the food on it looks good.

- A garlic press or forcing bag with nozzles will extrude noodles or spaghetti or decorations for cakes. Remember the clay must be extremely soft to be used in this way.

- Show the children pieces of fruit which they can model. Try half peeling a banana for an interesting effect which they could copy or peeling part of an apple and leaving the peel hanging off the fruit.

- How about a celebration cake, wedding or birthday, which could be decorated as exotically as you like with candles, cashews, horseshoes or a centre piece?

Far left Extruding clay noodles through a garlic press

Left Cutting chips from a clay slab

c. Patterns

- Roll out pieces of clay and impress with a variety of tools and objects.

- Tear the clay into different shapes.

- Use a template to cut patterns. Perhaps they could interlink to form a larger pattern.

- Make a simple plaster mould of an interesting pattern, then use this to impress the clay.

- To make beads, roll out shapes and press patterns on the surface. Push a knitting needle through the bead to make the hole.

Right Making patterns with a toy car

d. Games
Design a series of games

- Dominoes: roll out slabs of clay and, using a template, cut out the domino shapes. Decorate the tiles with whatever symbols you choose.

- Marbles: roll out balls of clay, and decorate.

- Snakes and ladders: roll out a board, then draw in the squares, numbers, snakes and ladders. Use tools to decorate the snakes and the edges of the board.

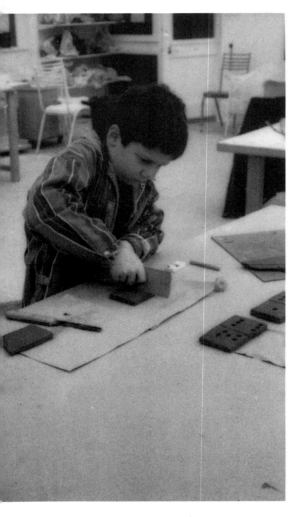

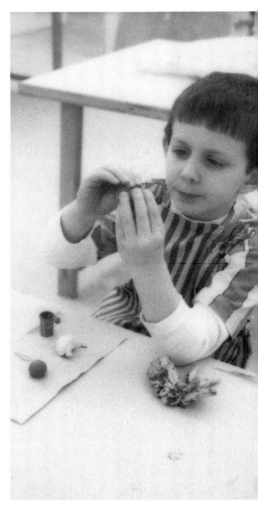

e. Beasts and mini-beasts

- Noah's Ark

- Pet shop

- Insects: beetles, (Egyptian scarabs), spiders

- Caterpillars

- Snails

Model them out of solid pieces of clay. Add coils and all the extra bits that make the work look interesting: eyes, feelers, patterns, etc.

- Owls can be made, using two pinch pots and fixing them together. Do this when the pots are still damp, but not too floppy. Beaks, eyes and textured feathers will complete the owl. Other animals or birds can be made this way. An exotic fish might be fun.

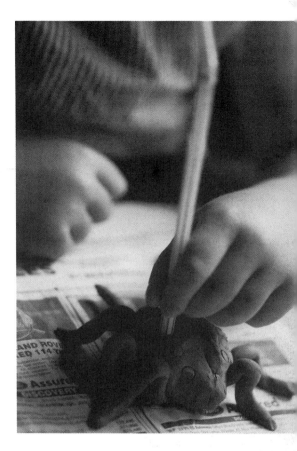

Far left Macon aged 7, impressing patterns into clay dominoes

Left Lewys aged 5 making beads and marbles

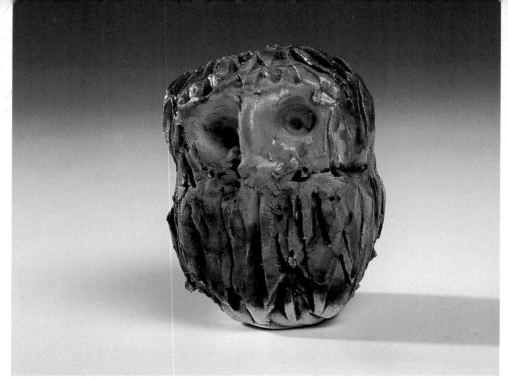

A pinch pot owl by Richard aged 7

A frog modelled by Ben aged 8

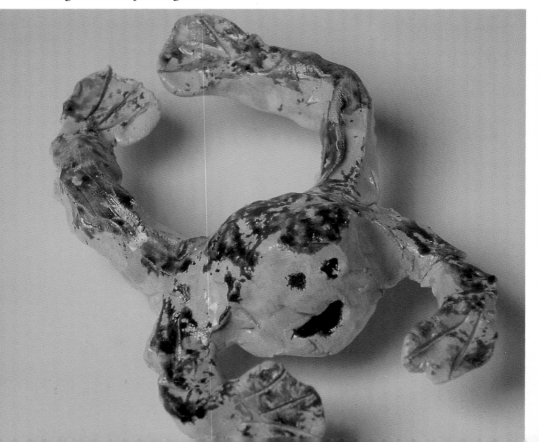

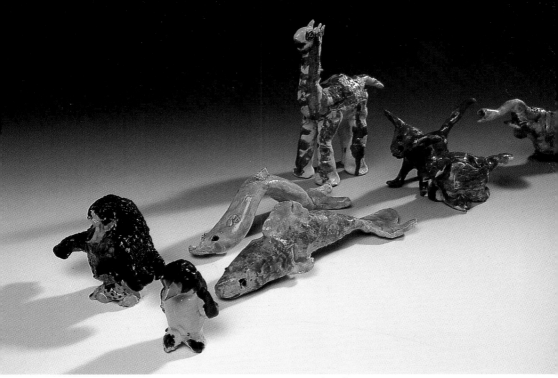

Noah's ark made by Class 7, Malton County Primary School

A snail and an anemone by Class 7, Malton County Primary School

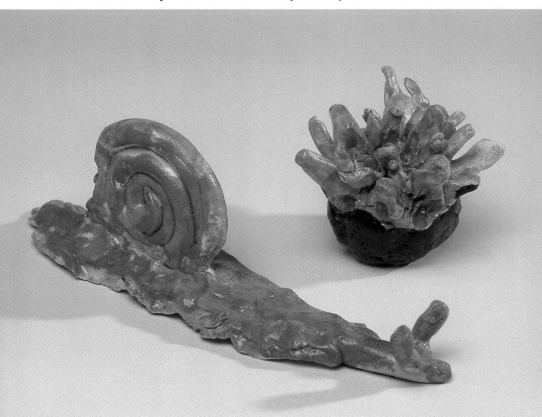

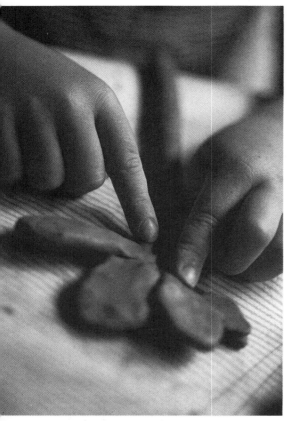

Making a flower

f. Forms from nature
(developing pinch pot shapes)

- Flower and fungi shapes can be achieved by pinching a pot shape, and then pinching the rim into thin frills. As you squeeze, the clay will crack and make interesting shapes.

- Hatching eggs: make two pinch pots to form the broken shell, and then model a crocodile, chick or bird. Place it popping out of the shell.

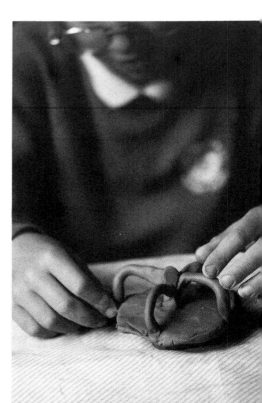

Making a roundabout

g. The playground

This could be a class project. Using a variety of techniques, a large model of a playground can be made. You could create a large scene on a table top or a big board.

- Try using sand, gravel or painted newspaper as the base. (Paint the newspaper with a mixture of glue and paint to make it thick and strong.)

 Cover with rolled out slabs of clay.

- Add figures made by using either the pipe cleaner or solid sculpture methods. Get lots of movement in bodies, arms and legs, by bending the clay at waist, head, etc. See pages 51 and 55.

- Put in trees, mark out games, add balls, build fences and so on.

- Buildings can be added. See page 46.

- This idea can be developed for lots of other projects – streets, markets, the seaside, the circus.

Making a slide

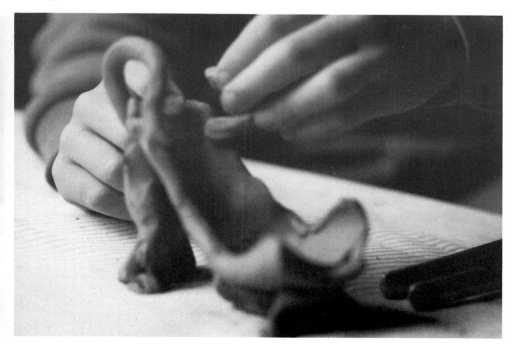

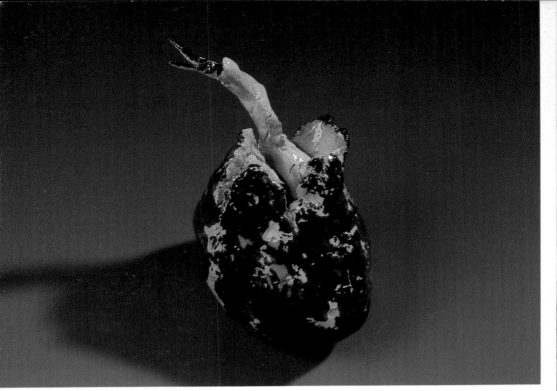

A hatching pinch pot egg by Macon aged 7

A street scene by Class 7, Malton County Primary School

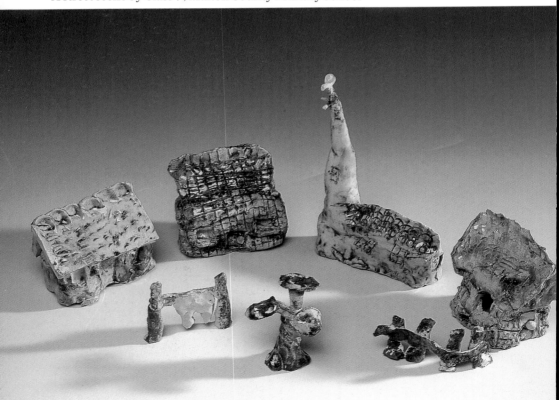

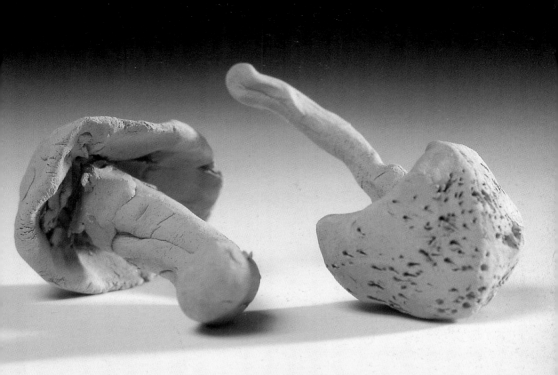

Unfired, pinched fungi shapes by Florence aged 5

Large feet made by Richard aged 7 and Alexander aged 6

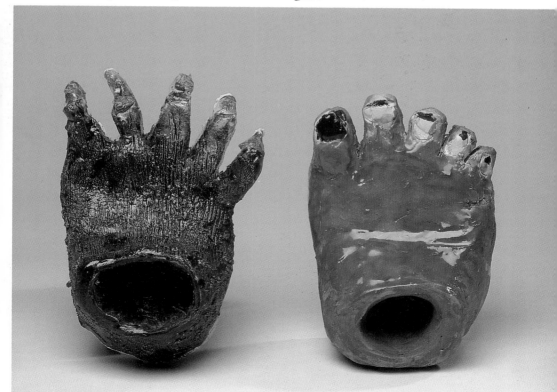

h. Giant hand, foot or mouth

- Shape your hand or foot out of a large lump of clay.

 Add toes by cutting into the lump and squeezing the clay into toe shapes; add fingers in the same way.

 Mark in the toe and fingernails. (It might be an idea to look at your own feet or hands, to help with proportions.)

- Make a monster's foot with claws. Carve any lines or markings and rough up the clay to suggest hair.

- Make a mouth by banging a block of clay into a large ball. Push your hand into the ball to open up the mouth area, then add teeth, tongue and a thick coil for the lips.

i. Buildings

Buildings can be made out of solid lumps of clay.

- Cut a square lump of clay from a new bag of clay, or knock a piece from the bin into a square.

This is the main block of the house.

Use a loop-ended modelling tool to carefully scoop the clay from the centre of the block, leaving an even wall all round.

Cut out window and doors.

Build the roof separately by rolling another slab. Cut the front and back of the roof and join by pinching the two edges together to form the ridge. Allow the walls to stiffen a little before adding the roof. Use small off-cuts of the slabs to fill in the gaps at both ends under the roof.

Add drain pipes, guttering, plants, chimney pots. Tiles could be marked on the roof. Letter box and door knobs, window panes and curtains would all add to the finished appearance.

This method of building could be adapted for any shape of building – churches, huts, igloos, castles and so on.

j. Plaster stamps

- Take a thick, flat piece of clay and push the end of a small rolling pin into it.

 Make a pattern in the bottom of the hole. We are going to make a plaster cast by filling this hole with plaster, so don't make the design too complicated. A simple pattern will make a better stamp.

When the plaster is set, peel the clay away.

Leave the stamp to dry out.

You can then use it to print patterns on clay. These patterned stamps are good for pressing on to thin pieces of clay which can then be stuck to the surface of pots to form raised decoration.

Clay slab impressed with plaster stamps

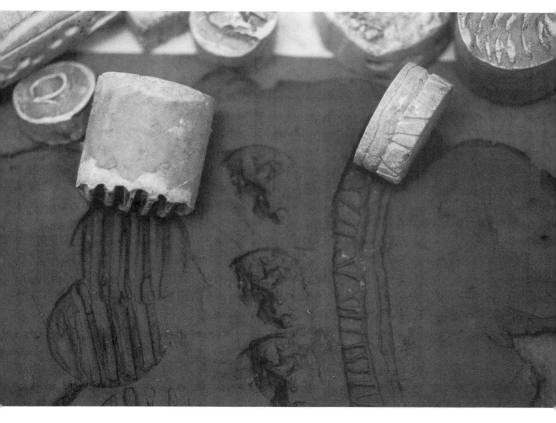

k. Team photograph

Football, cricket, netball

Roll out a base for the relief tile, and trim the edges to the shape you want.

Model the individual people for the picture. Model them flat on a board, pinching and adding to the figures. Before doing any final bits, stick the team on to the base. Remember to scratch and put slip on the two surfaces to be joined.

Sharpen up faces, clothes etc. and maybe add a bat or a ball.

Your team could stand or just be head and shoulders.

If you are going to fire the tile, holes can be put in the corners so that it can be hung.

Another way of doing this project would be as a three-dimensional sculpture. The children could work together to produce figures of the team, some standing, some kneeling or sitting. The figures could then be posed together, just like a team photograph. They could be mounted on a slab of clay or a board.

Eleanor modelling

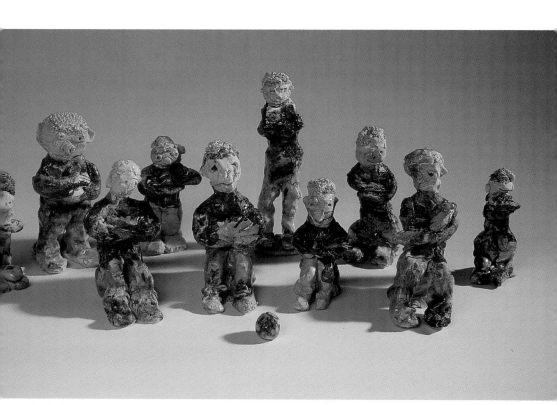

A football team by Class 7, Malton County Primary School
A cottage and stable by Class 7, Malton County Primary School

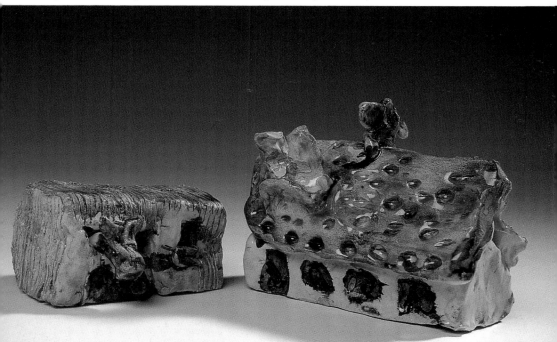

l. Tiles

Drawing into soft clay

- To make tiles, roll out clay on material. To get an even thickness, roll the clay out between two laths. Try to avoid really thin tiles. They often warp as they dry. Extra thick tiles can crack, so we're aiming for a happy medium – 1 cm ($\frac{3}{8}$ in) minimum.

Cut the tiles into the size you want. If you need them to be accurate, use a template or consider buying a tile cutter from one of the pottery suppliers. It is worth it if you want a large number of tiles.

Decorate the tile by carving, impressing, adding clay in coils or blobs.

Dry the tiles slowly to prevent warping.

Tiles could be used for class projects on almost any subject. The tiles could link to form one large picture of a clay map of the local area, an underwater or space scene or you could re-create a Roman floor.

A modelled tile

52

A group picture of all the children in a class or school makes a good record and is fun to make. Each child draws a self-portrait on a tile; head and shoulders is probably best, as more detail can be put into the face.

When designing the whole picture, think about adding a border of different shaped tiles. The border could have patterns pressed into it or added in relief. These larger projects look good mounted on boards as a permanent display.

Door plaque with duck

Door plaque with face

53

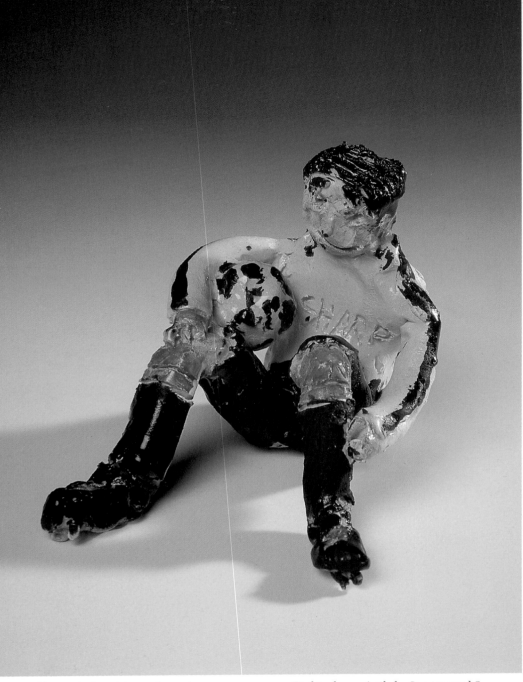

Above A pipe cleaner figure by
Christopher aged 10

Right, above A tile by Jenny aged 8

Right below Dressed pipe cleaner figures
by Eleanor and Flora aged 9

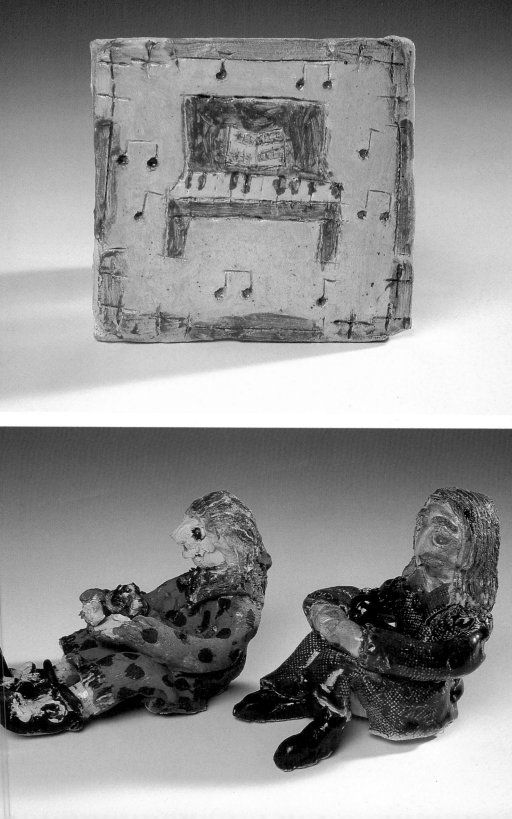

m. Pipe cleaner figures

This method produces great figures but they are fragile. It is based on coils and is probably best with older children.

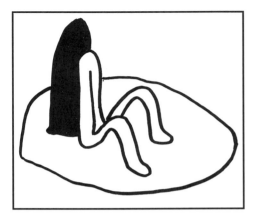

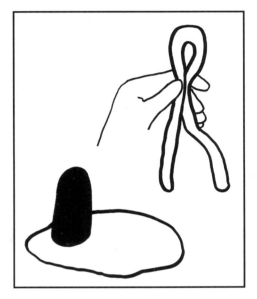

Roll out a coil of clay (see the project on coil pots, p.17), and bend it into a long, hairpin shape. Then bend this into a body and legs. Put it on to a board. It is best to work out the position of your figure in a sitting or leaning position, as standing causes problems of collapsing clay. Think of objects you could use – a seat or barrel or tree – to support the figure.

Your figure could have a base of rolled out or hand flattened clay.

Roll a smaller coil of clay for the arms. Use one piece only and again think of ways to bend the arms to give movement but also to give the best support. Fix the arms to the body, pressing the clay together very well using the scratch and slip method. Remember to use slip sparingly or your model will disintegrate.

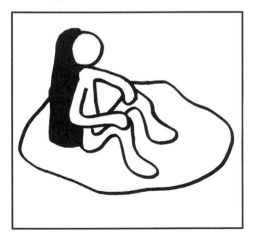

Next add the head. Make a ball of clay, squeeze a neck, and then model the face. Add it to the top of the body, working some of the clay

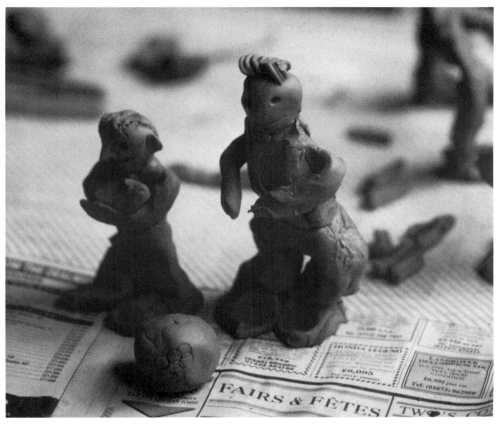

Pipe cleaner figures

down from the head into the body to make them as one.

The next stage is to 'dress' the model. Roll out the clay on different textured material – as thin as possible without the clay splitting – and cut pieces for trousers, jackets, skirts etc. Wrap them round the figure, allowing them to drape and show movement.

Add anything else appropriate. Imagination can run riot here. Select items from the texture tools to impress eyes, nostrils, ear holes and patterns on the clothes. Add buttons and earrings, watches or necklaces. You could add a hat, hang a bag over the arm or put a rucksack on the figure's back. Try a pair of spectacles or maybe a beard. Hair can be extruded from a garlic press or bits of clay can be added to the head and roughed up with a comb or hacksaw blade. How about adding an animal or a tree to your base?

Remember to join the pieces well.

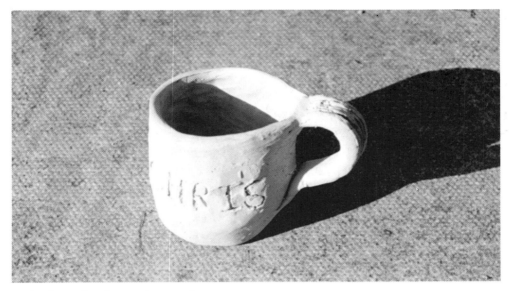

Unfired mug by Christopher aged 10

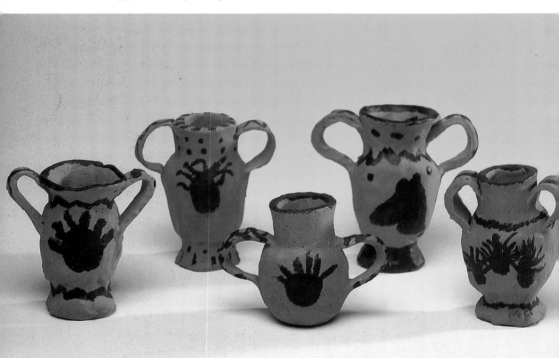

Unfired, painted clay Greek vases by Class 5/6, Headlands Primary School, York

n. Pots ancient and modern

- A medieval mug: a coil handle would make a pinch pot into a cup or beaker. Two handles, and you have a medieval mug. Decorate it with lettering.

- Plant pots for Mother's Day: make pinch pots, decorate and fire them. They can then be filled with earth and a small plant.

- A Greek vase: make a pinch pot and then try adding a coil to the top of a pot to make a rim. A base can be made from a small, pinched cup shape turned upside down and fixed to the base of the pot. Next, roll a coil and make two handles. Fix these carefully in place. To decorate, paint it with the usual mix of 50% ready-mix paint and 50% PVA. Use terracotta, ochre, black or white to give your pot an authentic look. The children could copy designs from books on the Greeks.

A coiled jug by Robert aged 8

Chapter Four
Prospecting for local clay

Clay occurs commonly right across the earth's surface. It is easy to find, and interesting to prepare and condition for use. When out in the countryside or even on a town walk, you will come across clay.

Signs to look for

Clay is normally a different colour from the soil and might range from grey to pale cream through orangey yellow to brick red and chocolate brown. It occurs in seams or beds and can often be spotted in an eroded river bank or cliff. Wherever roadworks or building sites occur, the excavations will turn up layers of clay and workmen will often be able to indicate clay to the prospector.

Clay holds water, so another frequent indication of a clay deposit is where water puddles on a pathway or in a field.

To test for suitable clay out in the field, simply scoop a little into your fingers and roll it into a coil. If the clay is going to be plastic and suitable for use, you will be able to bend the coil into a knot. Clay which contains too much sand or gravel will break up and crack when you perform this test. If the clay deposit is hard, simply collect it in lump form.

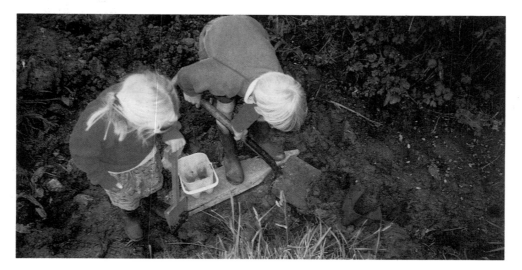

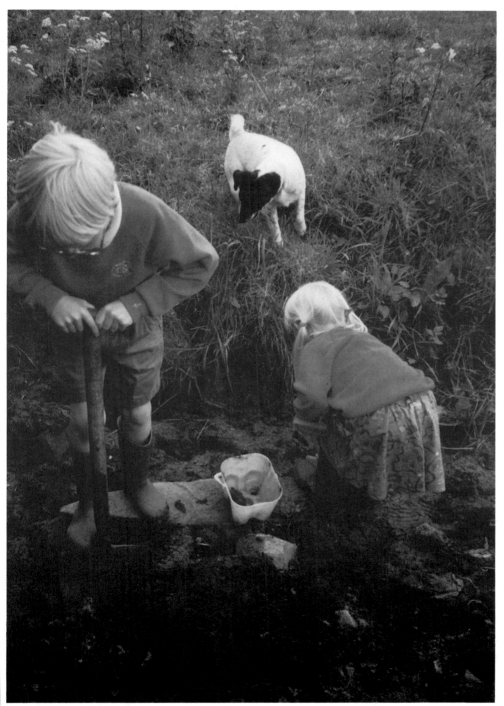

Left and above Children prospecting for clay

You will need

a trowel or spade; strong plastic carrier bags; wet wipes or a cloth to clean hands on; a plastic bucket or bowl, an absorbent bat or surface, a rolling pin

What to do

If you have found a good source of clay, use a trowel to dig out a sample. You will need a stout polythene bag to carry your clay. Remember that it is heavy stuff so do not overload yourself. It is also a good idea to take along something with which to wipe clean your hands.

Your bag of newly found plastic clay should be kept tightly shut to keep the moisture content up.

To prepare it for use, you need to remove any organic matter or stones that are mixed in by pinching off small pieces from the main lump. Squeeze the small pieces between your fingers and, as you do so, feel for and remove any stones, sticks, leaves, moss etc.

This simple cleaning process should leave you with soft clay which you should pat into a lump and knead for a few seconds before using.

Hard lumps should be left out in the open to dry off completely. Try to break the lumps into smaller pieces – a rolling pin might help. Then simply spread them out to dry.

Clay that has dried completely will look much lighter in colour. Fill a plastic bowl halfway with water and add the dried clay lumps. If the clay is properly dry you will hear it hiss as it rapidly absorbs the water.

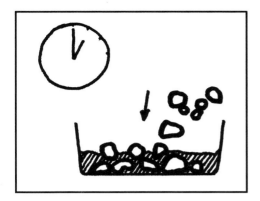

Leave the clay in the bowl to stand undisturbed for at least two hours. Do not stir. Make sure that the water covers the clay. This wetting process will result in the break-up of the hard clay into a 'slurry' (liquid clay) at the bottom of the bowl.

After two hours, decant the clear water from the top of the slurry by simply tipping the bowl sideways. Give the slurry a quick stir, then allow to dry out until the surface has stopped shining.

If you have space, the slurry can be spread out on an absorbent surface, such as untreated wood, paving slab, or plaster of Paris bat. This will speed the drying process considerably.

You must keep checking to see if the surface of the clay has stopped shining or it will dry too much and have to be wetted down once more. Roll and pat the drying slurry into a lump and knead it for a few seconds before using. Keep newly processed clay in an airtight container.

Developments

Prospecting for clay can cross the curriculum into geography or science lessons and might become part of field study trips or nature walks.

A processing area can be set up in the classroom to contain any mess and to record the procedure and results by making charts and maps.

There may be a local brickyard that could be visited. Many have their own clay pit and the children could follow the process from the mining of the clay to the finished tiles and bricks. This would tie in with projects on buildings.

A range of clay can be collected from different localities and treated separately to compare colour and content. Different colours could be sieved after soaking and kept as slip (liquid clay) in screw-topped jars. Slip can be used as an elementary paint for cave paintings or body paint.

Clay found by children can be used for artwork in the same way as bought clay.

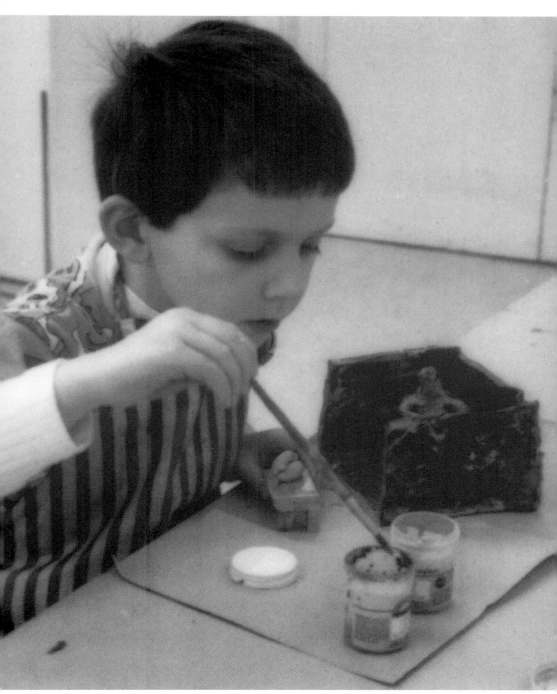

Lewys applying brush-on glaze to his soft slab room

Chapter Five
Firing

Firing is not an essential part of claywork in the primary classroom, but if you have access to a kiln, it is great for the children to see their work transformed from malleable clay into resilient pottery.

Before working with any kind of kiln in school, you must read the relevant health and safety rules.

There are many different ways of firing your work, and many different books have been written on the subject (see the list of useful books at the back of the book, page 71). As you become more confident, perhaps you can experiment with sawdust or pit firings, but our aim here is to give simple instructions on the firing of an electric kiln. This is the most likely one to be found in schools.

Firing an electric kiln

Kilns may vary in size, shape and types of controllers, but it is simply a brick or fibre chamber lined with elements. It works on the same principle as the domestic oven. Look and see what you have with your kiln. Do you have shelves and props? What kind of temperature control does it have? Some kilns have controls that can be programmed to fire and turn off when temperature is reached.

The first firing of work is called the **biscuit firing**. The temperature for a biscuit firing is 1000° Centigrade. This temperature is reached over a long period of time, to drive off any moisture and to slowly change the clay into pot. This is especially important with unevenly thick work. A fast firing will lead to cracked work.
A second firing can be done. This is after you have applied glaze and is called the **glaze firing**. The temperature for this firing will depend on the glaze used. Follow the makers' instructions. It may be higher than the biscuit firing.

Kiln regulo

Method

Make sure all the work is bone dry. This is very important. The pieces should be of an even colour without dark shadows which would indicate dampness.

Raw, dry clay work (greenware) may be packed closely. The pieces can touch and can be stacked one inside the other. Place the heaviest pieces at the bottom when stacking. If you are using kiln shelves, make sure the props are aligned one above the other to stop the shelves sagging.

Make sure none of the clay work is touching the elements.

Close and lock the door.

Leave any bungs out and turn on the lowest regulo.

With thick and uneven work, it is a good thing to leave the kiln on overnight with just a whisper of heat, if possible.

If the kiln regulator is calibrated up to 100, increase the temperature by 10 every hour until it reads 70, then put the bungs in and turn up to full. Fire to 1000°C.

If the regulo reads 'low, medium, high', switch on at low for three hours, and then medium for three hours. When your temperature gauge reads 700°C, turn up to full, put the bungs in and fire to 1000°C. These are only general guidelines. If you have different instructions relating to your kiln, then follow those.

Kilns take as long to cool down as they do to fire. Do not open the door of the kiln until the temperature has dropped to below 100°C.

The fired ware can now have the glaze applied and be fired again, or it can be painted, varnished or simply left as it is.

Glaze firing

Glaze is a glassy coat which is applied in liquid form, just like paint. Mixing glaze from raw materials is too complex for the primary classroom. There is a brush-on form of glaze which is ideal for children. It comes ready mixed in a thickened fluid form, dries hard and doesn't flake off. It is safe and easy to use and there are many good colours. You will get the best colour response on white or buff clay. Alternatively, prepared glaze can be purchased in powder form. It is ready to mix with water. After mixing, it will need sieving into a bucket with a lid and will require stirring well each time before use. The clay pieces can be dipped into the glaze. As it dries, the glaze will form a powdery surface on the work. Try not to handle it much, as you will remove the glaze.

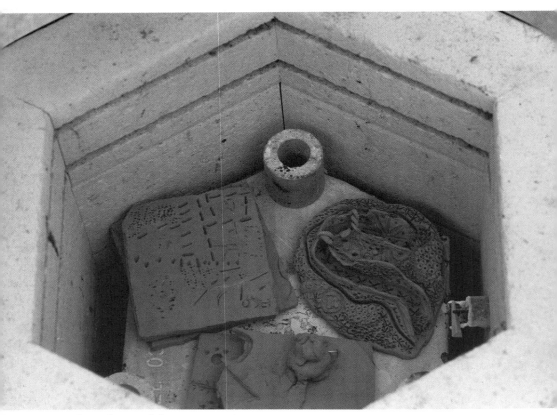

Loading a biscuit kiln

Glazed ware must have its base wiped clean, together with a small section up the side of the piece. This is to stop it sticking to the kiln shelf. Wipe the glaze off with a damp sponge or cloth.

The pieces must not touch each other or the sides of the kiln, so pack it carefully, making use of the shelves.

Leave the bungs out and close the door. Lock it.

The temperature rise for glaze firings can be more rapid than for the biscuit firing.

Turn on the kiln with the regulator at a low setting, for one hour. Turn the regulo up to halfway for a further hour. Turn up to full, pop the bungs in, and fire to the temperature recommended on the glaze bottle or packet.

This firing will take a long time to cool down. Don't be tempted to open the door; you will crack the pots!

If you feel unsure about firing the kiln, there is certain to be a potter or ceramics teacher not too far

from your school. In our experience, potters are only too happy to help. Why not find out if there is a local pottery group? There are organisations all over the country. Perhaps local galleries could help track some down. Many potters fire work for local schools, charging for the power, which isn't a vast amount.

Unloading a glaze firing

Glossary
Some common terms explained

Slip A liquid clay. It is used to bond pieces of clay together. To make slip, pop some small pieces of clay into a pot – a plastic cup would do – add a small amount of water and mix with a brush or stick until a thick cream is formed.

Another way of making slip is to put a ball of clay on the work table, stick your thumb into the ball, then fill the hollow with water. As the children need slip, they can stir a brush around in the water. It will mix with the clay and make slip.

Coloured slips Liquid clays with colours added. They are painted on to raw clay and after biscuit firing; a transparent glaze can be put over the work. This will show off the good colour range it is possible to get. Slips are not difficult to make up, but it is yet another job which you may well find you can do without! They can be bought ready prepared.

Glazes A glass-like covering, which makes a pot watertight, as well as giving a smooth, colourful appearance. It is possible to mix your own glazes, but this is difficult in school. Pottery suppliers sell ready to mix glazes, which you can store in buckets with lids. They also sell ready-mixed glazes in bottles which are easy to use and come in a wide range of colours. They are applied with a brush and dry hard on the work, which means they do not flake and brush off like other glazes, and are easier and less hazardous to handle.

Coil A rolled sausage shaped piece of clay.

Earthenware A description of work fired between 1040°C and 1200°C.

Biscuit fire First firing of a pot, without glaze.

Glaze fire Second firing of a pot with glaze painted on.

Score To rough up a surface.

Greenware A raw (unfired) piece of work.

Props Tubular pieces of firebrick used for building up the shelves in a kiln.

List of Suppliers

UK

Bath Potters' Supplies
2 Dorset Close
East Twerton, Bath BA2 3RF
Tel. 01225–337046

Briar Wheels and Supplies Ltd.
Whitsbury Road, Fordingbridge
Hants, SP6 1NQ
Tel. 01425–52991

Potclays Ltd.
Brickkiln Lane
Etruria, Stoke-on-Trent ST4 7BP
Tel. 01782–219816

Potterycrafts/Reward-Clayglaze
 Ltd.
Campbell Road
Stoke-on-Trent ST4 4ET
Tel. 01782–272444

US

American Art Clay Co., Inc.
4717 West Sixteenth Street
Indianapolis, IN 46222

Axner Pottery Supply
P.O. Box 1484
Oviedo, FL 32765

Continental Clay Co.
1101 Stinson Blvd. North East
Minneapolis, MN 55413

Georgies Ceramic & Clay Co.
756 North East Lombard
Portland, OR 97211

Texas Pottery Supply
P.O. Box 161305
801 D Airway Drive
Fort Worth, TX 76106

Reading list

Clough, Peter, *Clay in the Primary School*, A&C Black, Davis Publications, 1996.
Lancaster, J. (ed.), *Art, Craft and Design in the Primary School*, NSEAD, 1986.
Nigrosh, Leon, *Low Fire*, Davis Publications, 1980.
Nigrosh, Leon, *Sculpting Clay*, Davis Publications, 1992.

Perryman, Jane, *Smoke-fired Pottery*, A&C Black, 1995
Taylor, R., *Educating for Art*, Longman, 1986.
Topal, C. W., *Children, Clay and Sculpture*, Davis Publications, 1983.

Index